SENATVSI

IMPCAESAR

TRAIANO·A

MAXIMO·TR

ADDECLARA

MONSETLOCVS

THE PRACTICAL GUIDE TO

Calligraphy

Rosemary Sassoon

Thames and Hudson

Frontispiece: Part of an inscription on the base of Trajan's Column in Rome, dated AD 114. It was from such fine incised letters as these, produced at the height of Roman civilization, that our alphabet developed. Changing tools from a chisel cutting into stone to a quill writing on vellum or paper meant modifying the letter forms, until the written alphabet as we know it gradually emerged.

CONTENTS

Introduction – 6

1 Tools and materials – 8 2 Starting to work – 10

3 The construction of the letters – 12

4 The Foundational Hand – 14 5 Using the pen – 20

6 Critical analysis – 22 7 Simple layouts – 26

8 Introducing colour – 29 9 Left-handed calligraphy – 30

10 Other basic alphabets – 32

11 Combining different hands – 46 12 Flourishes – 52

13 Materials for more advanced work – 58

14 Studying and using historical hands – 60

15 Display lettering – 70 16 Brush lettering – 74

17 Preparing work for reproduction – 78

18 Calligraphy at work – 80

Additional reading – 95

List of suppliers – 96

Acknowledgments – 96

INTRODUCTION

THE WORD CALLIGRAPHY is derived from the Greek *kalle graphe*, meaning beautiful writing. Today, however, it suggests different things to different people; at one extreme just fine handwriting, at the other a highly creative art form. The scholar can, through ancient manuscripts, study the history and development of writing as reflecting the rise and fall of civilizations, while the letterer, stone carver or typographer uses the same manuscripts searching for inspiration from the classic letter forms.

It is arguable whether calligraphy should be termed an art or a craft. It is a craft in the sense that the discipline and training of hand and eye, and the use and respect of natural materials, demand a craftsman's skill, but the skill itself is only a tool and the beginning of the creative aspect – the interpreting of the deeper meaning of the written word as a visual art form.

Whatever way the word is understood, calligraphy must essentially be *used*, otherwise learning it becomes a sterile exercise. It can be used in many ways. There is always a demand for the traditional work of a scribe: presentation lettering of all sorts, rolls of honour, family trees, heraldry and even handwritten books.

There is also an increasing need for calligraphy in commercial art and printers' studios or architects' and draughtsmen's offices. Despite the wide range of 'instant' lettering now available, designers realize that there is no substitute for the versatility of hand lettering, and are turning to the small band of experienced letterers whose skills have often been underrated or ignored.

The first part of this book, which is largely based on my own teaching experience, is intended for the beginner who wishes to

acquire the basic calligraphic skills and put them into practice. In it I have made use of the plain and beautiful 'Foundational Hand' which was evolved from traditional English book hands by Edward Johnston (1872–1944); this, together with a number of variations, helps to develop the basic skills before the student goes on to experiment with some of the many historical alphabets bequeathed to us from the past. A few of these are set out in the second part of the book.

I believe that by learning to analyze and group together letters comprising similar strokes, the student can make more rapid improvement both in the early stages and later on, when this method leads to a quick grasp of the angle or particular characteristic of any new hand. The inventive calligrapher will soon find means of self-expression through the choice of letter forms and the uses to which these can be put; and such creativity should, in my view, be attempted at an early stage. I have suggested a number of practical uses for calligraphy in the second part of the book and have also included advice on preparing work for reproduction, an increasingly important aspect of the calligrapher's work. By showing some examples of my own professional work, each with a specific point to make, I also hope to give a picture of the varied life of the working letterer.

Whether calligraphy is to be used for profit or pleasure, the learning methods are the same. They are neither quick nor easy but they need not be repetitive and they should certainly never become dull. The practice of calligraphy provides a freedom of expression and makes one better able to appreciate the work done by other artists and craftsmen. It will repay in full the time you give to it.

1 Tools and materials

A beginner needs very little equipment. Use an ordinary drawing board, supported on your lap, leaning it against a steady table at a comfortable writing angle. Never try to do lettering with your work flat on a table. Pin some sheets of newspaper to the board to make a resilient working surface. Use a sheet of good quality cartridge paper, kept in place by a horizontal band of elastic. Everyone has an optimum writing position and the paper should be easily movable up and down or side to side to ensure that the hand is neither cramped nor overstretched when writing.

A double pencil is the best tool to begin with. To make one, take two short pencils, pare down one side of each and fit them together so that their points are even and about 1/8 inch apart; then fasten them with adhesive tape or thread.

For lettering with a pen, round-hand nibs can be bought separately or in sets. A selection ranging from the broadest, size 0, to the narrowest, size 6, will eventually be needed. The nibs must have a slip-on reservoir to hold ink, or be used in a penholder which has a reservoir attached. Straight nibs are needed for right-handers and left oblique nibs for left-handers. Non-waterproof ink or liquid watercolour are both used for calligraphy. Waterproof Indian ink is unsuitable as it clogs the pens.

A metal ruler, a set square and a hard pencil are needed for drawing lines, a small paintbrush for feeding ink into the reservoirs, a jar of water, a soft rubber – and that is all that is necessary.

Equipment

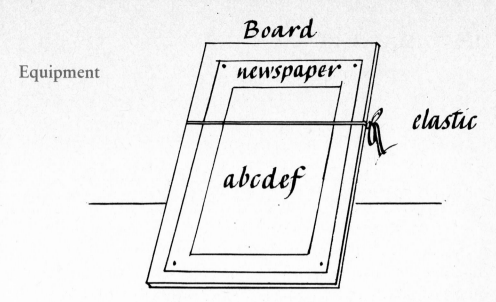

Lean the board against a table at a comfortable writing angle. Pin a pad of newspaper to the board and tie a length of elastic to hold the work in place.

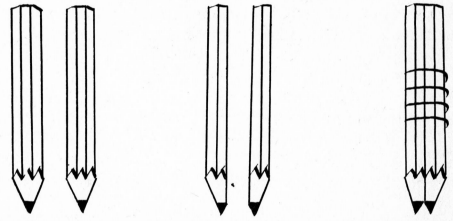

To make a double pencil, take two short pencils, pare down one side and fasten together.

Round hand pens

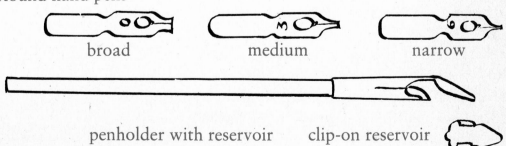

broad medium narrow

penholder with reservoir clip-on reservoir

2 Starting to work

Hold the double pencil or pen in a firm, comfortable grip, so that the two points of the pencil, or the nib, are at an angle of 30° to the guide lines.

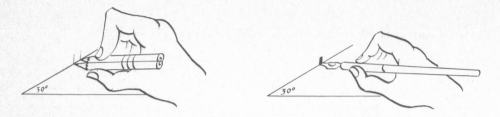

The thickest stroke will then be the diagonal from top left to bottom right, and the thinnest stroke from bottom left to top **right**. The upright and horizontal strokes are of medium weight.

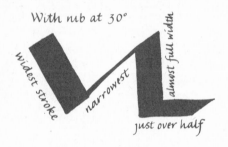

With nib at 30°
widest stroke
narrowest
just over half
almost full width

Practising the patterns that are illustrated on the opposite page, and inventing new ones, will teach control of the double pencil or pen. The writing implement must be kept at a constant angle. In the early stages it is a good idea to check the 30° occasionally with a protractor. Too sharp an angle makes the upright strokes weak, too shallow an angle makes them heavy. Accurate guidelines are essential. Correctly measured lines ensure correct weight and proportion of letter. Use a hard, sharp pencil to draw lines, and lay out your first pages with a margin and plenty of space between the sets of lines, making it easy to judge and improve your work.

Lettering is a mixture of discipline and relaxation, conformity and creativity. There are a few rules that must be followed and a plain, well-proportioned hand should be learned first. In fact 'Plain is beautiful' is a good motto for beginners.

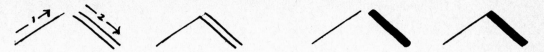

Thin upstroke left to right, thick downstroke left to right.

Patterns based on letter shapes are good preparation for writing.

3 The construction of the letters

When starting double pencil or pen lettering, tackle the easiest letters first. They are shown here in their simplest form, but these can be used when learning any subsequent alphabet.

iljnmrhu **iljnmrhu**

First the letters constructed with straight lines and arches.

minimum **minimum**

Practise words containing these letters only.

ocebdpq **ocebdpq**

The letters based on the 'o' shape alone, or with upright strokes.

cope bode **cope bode**

Words to practise.

agy **agy**

Simplified versions of a, g and y, using the same strokes as above.

agkftz **agkftz**

More complex letters and those using horizontal and diagonal strokes.

svwxy **svwxy**

This non-serif alphabet is used here to analyze the shapes of letters and as a preparation for the Foundational Hand on the following pages. For instructions on guide-lines to ensure correct proportion and the order and direction of writing the strokes see p. 15.

Details and terminals of Foundational Hand small letters

Serifs (i.e. the introductory stroke at the top of the letter) neaten the upright strokes standing on their own, as in b, k and l – also i and j and the second stroke of u. Serifs are written in three separate

strokes. After the first two strokes the pen is at the correct angle for the downstroke. The top of the t also takes three strokes.

Upright strokes followed by an arch start with a slight swing left to right, as in n, m and r. An upright preceded by a curved stroke starts with an oblique right-to-left hairline. For a well-rounded arch, start the second stroke at the outer edge of the upright.

The diagonal stroke is neatened by a slight swing at the start of the stroke or a separate horizontal stroke followed by a thin diagonal.

Bases for f, k, q and p as well as x are written in two separate strokes.

 muai

Other bases are formed by a left-to-right swing at the end of the downstroke. The last stroke of multiple letters, and uprights standing alone, need larger bases to balance them.

Junctions: notice the point of the 'v' and how two curved strokes join.

13

4 The Foundational Hand

Guide lines for the Foundational Hand should be $4\frac{1}{2}$ times the distance between the two sharpened points. Letters such as o, s and x with no ascending or descending strokes are written between these two lines. The height of these letters is called 'x height'. Notice that the ascenders and descenders of letters b, d, y, p, etc., extend to $1\frac{1}{2}$ times x height. It is not necessary to draw guide lines for them. Each stroke in formal calligraphy is separate, firm and unhurried.

In the lower alphabet the separate strokes that make up each letter are numbered in the order that they should be written, and arrowed to show in which direction they should go. The pen or pencil must never be pushed or forced in the wrong direction, e.g. letters such as o, s, c, or e, which are written in one movement in our ordinary handwriting, need to be lettered in two or three separate strokes.

The double pencil will show very clearly any faults in the shape and angle of the lettering. Watch the shape of the inside of each letter as well as the outside, and keep the upright strokes steady, just turning them at the bottom to make the base.

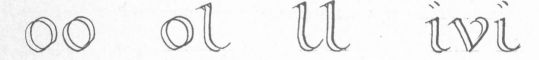

To make an evenly spaced word, differently shaped letters need different amounts of space between them. Two round letters should be written close together, round letters followed by a straight letter need more space between them and two straight letters need most of all. If these simple rules are kept in mind, even spacing comes with practise. It is not so much a matter of measuring as of training the eye.

It is well worth spending time perfecting the shape of each letter and practising the spacing of short words, then sentences in small letters, before starting capital letters. The space between words should be the equivalent of a letter 'o'.

Small letters written with a double pencil

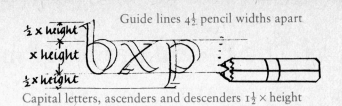

½ × height
x height
½ × height

Capital letters, ascenders and descenders 1½ × height

a b c d e f g h i j k l m

n o p q r s t u v w

x y z Simpler alternatives a g y

Arrows show the direction and order in which the strokes should be written after the serif has been completed.

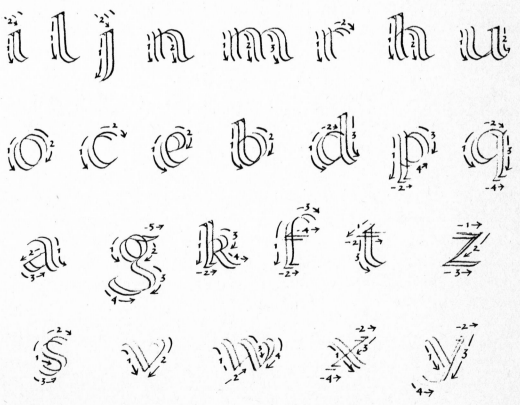

15

Foundational Hand: Capital letters

When writing capital letters only, guide lines should be 7 double pencil or pen widths apart. In general lettering, where capital letters extend to $1\frac{1}{2}$ times x height, the eye will soon manage to judge this accurately and guide lines will no longer be needed.

Make sure the strokes are written in the right order, as shown opposite, and change the angle for the third stroke of the 'N'.

To facilitate learning, Foundational Hand capital letters can be divided into sequences according to strokes and shape. They are shown here in a simple non-serif form.

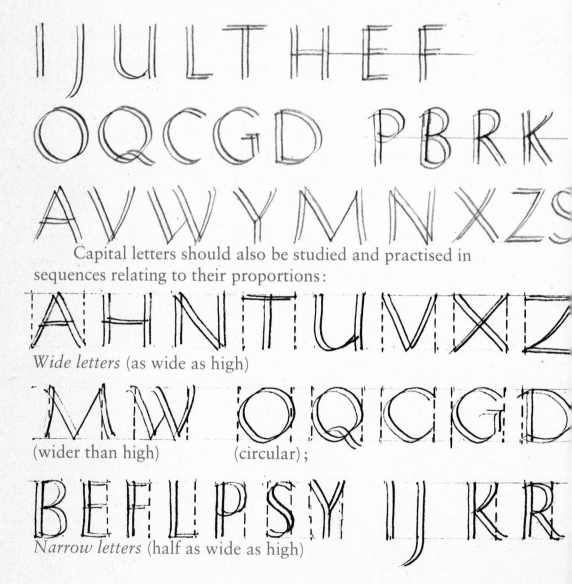

Capital letters should also be studied and practised in sequences relating to their proportions:

Wide letters (as wide as high)

(wider than high) (circular);

Narrow letters (half as wide as high)

Foundational Hand:
Capital letters written with
a double pencil

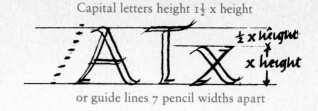

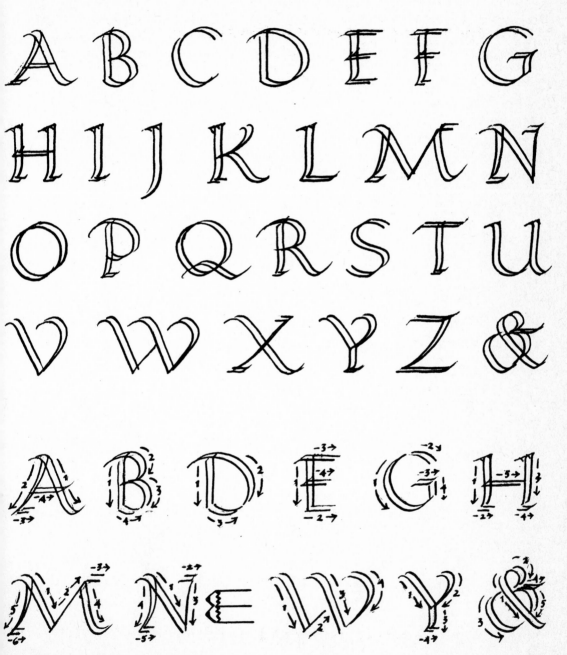

17

start

large

Measure the guide lines carefully
each time the double pencil is
re-sharpened

as you im-

prove reduce

the size by paring

more from inside

both pencils

In this example words are emphasized by shading in the lettering

18

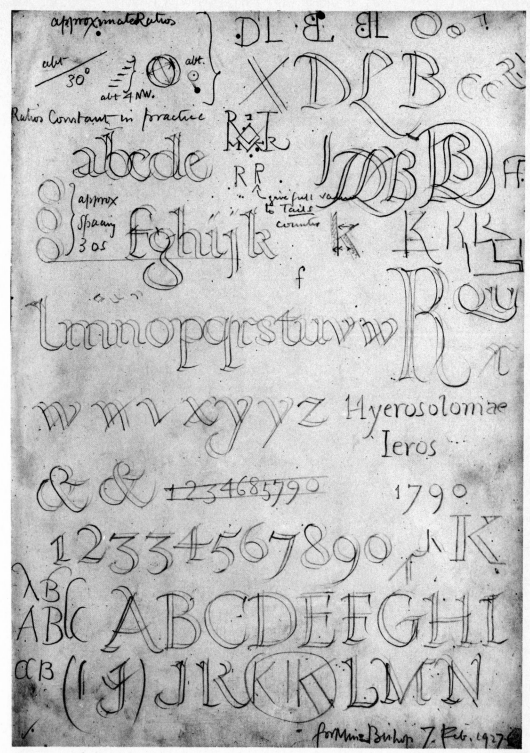

A page of double pencil work by Edward Johnston (reduced).
Reproduced by kind permission of Dorothy Mahoney.

5 Using the pen

Choose a broad nib to start with. Fit the pen nib into the penholder and hold it up to the light to check that the split in the nib is not being forced open by too much pressure from the reservoir, which should just touch the inside of the nib.

Use a brush to feed some ink into the reservoir but do not overfill. Avoid dipping the pen into the inkpot because this can easily flood the nib. When using a broad nib you may need to refill with ink after every three or four letters. Support your hand on a small sheet of paper in order to keep your work clean, and to test your pen on each time it is filled.

Draw the guide lines for small letters $4\frac{1}{2}$ pen widths apart. Two or more lines of writing must be spaced at least $1\frac{1}{2}$ times this measurement apart to allow room for ascending and descending strokes. Lines consisting only of capital letters can be spaced closer together. Practise the letters in the sequences shown on page 12, not in alphabetical order. The serifs and bases of letters must be clear and sharp. The flick of the pen, either freely upwards or edged downwards, terminating strokes, will come with practise and must not be exaggerated. Firm uprights and horizontals, and keeping the pen at a consistent angle, are more important in the early stages.

Numerals are usually written with the even numbers extending above the line and the odd numbers below the line, only 0 and 1 are between the guidelines. The tails of the descending numbers and the top of 6 need only the inner edge of pen or pencil to follow through and finish off the stroke.

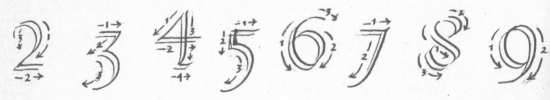

20

**Foundational Hand
alphabet written
with a pen**

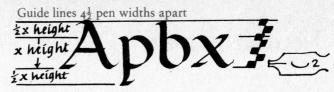

½ x height
x height
½ x height

Capital letters, descenders and descenders 1½ x height

abcdefghijklm
nopqrstuvw
xyz?, Simpler alternatives agy

ABCDEFG
HIJKLMN
OPQRSTU
VWXYZ&
1234567890

21

6 Critical analysis

It is important to know how to criticize, to analyze the faults, and to repeat a piece of lettering until it improves, keeping earlier copies for comparison.

Below is a reduction of a poem (one of Ariel's songs from Shakespeare's 'The Tempest') that I wrote out when I was a student. It was the third attempt. I have used words from all three copies in the analysis (on p. 24). The writing is already sharp and rhythmic with fairly firm uprights. However, there are still typical examples of poorly formed letters and unevenly spaced words on every line. Taking the poem line by line gives an idea of how closely lettering can be scrutinized. Look at the o's: they vary in shape. Many of the e's are too sharply angled, and the s's present problems of shape and spacing. Judging where to start an s so that its last stroke just touches the preceding letter is the sort of thing that comes only with practise. Some of the hairlines are exaggerated and the odd upright slants forward. A few letters are either too large or too small.

Full fathom five thy father lies
Of his bones are corals made
Those are pearls that were his eyes
Nothing of him that doth fade
But do suffer a sea change
Into something rich and strange
Sea nymphs hourly ring his knell
Hark now I do hear them
Ding, dong bell

falling forward

Full fathom five thy father lies
below the line *below the line* *too close*

Of his bones are corals made
too close *poor join* *slanting* *too close*

Those are pearls that were his eyes
below the line *too angled* *base too small* *sloping forward* *too close*

Nothing of him that doth fade
too close *below line* *too angled* *narrow*

hair lines exaggerated

But do suffer a sea change
narrow *too angled*

Into something rich and strange
slightly too close *this is the best written line*

Sea nymphs hourly ring his knell
too angled *poor join* *too close & narrow* *wide* *too close*

Hark now I do hear them
small base *cramped & heavy* *too angled* *sloping forward*

Ding, dong bell
short

too angled *sloping*

23

The capital letters are unsteady and of a less good standard than the rest of the lettering, as is usual in beginners' work.

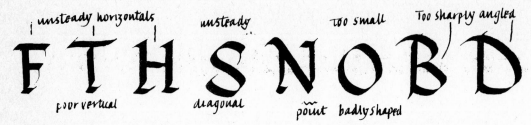

Some of the better words produced in the same size as the original.

something rich

hourly coral

knell strange

These examples show how letters can be modified in different combinations and how others can be linked to make the spacing more even and the writing flow.

is suffer fa hy

eyes are hear

This is a later exercise (reduced) with slightly more even spacing and with the letters more upright and better formed. However, there are some ugly collisions of ascenders and descenders that require replanning or more widely spaced lines. The capital letters are still unsteady, and the s's are again causing trouble, except at the beginning of words. The o's and e's are improved.

Had I the heavens' embroidered cloths,
Enwrought with golden and silver light,
The blue and the dim and the dark cloths
Of night and light and the half light,
I would spread the cloths under your feet:
But I, being poor, have only my dreams;
I have spread my dreams under your feet;
Tread softly, because you tread on my dreams.

Notice how the r's are flicked up at the end of words or before a round stroke, but downwards before an upright stroke ('dark'). Even small variations give a different pattern and character to the piece.

light, cloth under

embroidered dark

As your hand improves you may reduce the size of the lettering by using a smaller nib.

7 Simple layouts

Certain decisions must be taken even before pencil is put to paper – approximately what size is desired and whether a horizontal or vertical layout suits the subject matter. Then a series of thumb-nail sketches in pencil should be done, roughly indicating the title, block or blocks of text, number of words in a line, and any decorative features, such as illustrations or initial letters, before planning the size of lettering and measurements for guide lines.

This Exhibition of
FURNITURE
Will be open to the public Monday
to Friday, from 10 a.m. to 5 p.m.
Admission free

Write out each line separately. Find the *visual* centre and arrange the lines on a central axis.

This Exhibition of
FURNITURE
Will be open to the public Monday
to Friday, from 10 a.m. to 5 p.m.
Admission free

COME
TO THE
PARTY
on
Saturday
at
my house
JANE

7 p.m.-midnight

Caroline
Invites you
To
Tea
Sunday
June 5th.
2 Porter Rd.
Any time
After 4 p.m.

R.S.V.P.
30310

Lines of capital letters only, lines with few ascenders and descenders, and very short lines which are easily legible, can all be spaced closer together than $1\frac{1}{2}$ times the x height if desired. Layouts can be lined up to either left or right margins.

TUESDAY
Link-up

Consider the overall shape and the margins of any layout, particularly when spacing lines of different sized lettering. Lines that are too widely spaced lose coherence as a block.

This exercise, which I did as a student, worked out quite well, at the first attempt, for the first ten lines.

I will lift up mine eyes unto the hills
from whence cometh my help. My
help cometh even from the Lord who
hath made Heaven and Earth . He
will not suffer thy foot to be moved
& he that keepeth thee shall not sleep
Behold he that keepeth Israel: shall
neither slumber nor sleep. The Lord
himself is thy keeper the Lord is thy
defence upon thy right hand; so that

the sun shall not burn thee by day nei
ther the moon by night. The Lord shall
preserve thee from all evil: yea it is
even he that shall keep thy soul. The
Lord shall preserve thy going out and
thy coming in: from this day forth ev
en forevermore.

The last seven lines need re-arranging. By spacing out the first line and moving the last word or half-word on each line to the beginning of the next, a better shape will be achieved without awkward division of words. 'Even forevermore' can then be written centrally on the last line.

I will lift up mine eyes unto the hills
from whence cometh my help.
My help cometh even from the Lord
who hath made Heaven and Earth .

If it proves necessary to change a text radically, the rough copy should be cut up and re-arranged in a completely different shape. In this case I preferred a more formal arrangement on a central axis.

8 Introducing colour

Contrasts of colour and weight bring lettering to life. Start using colour as soon as you like for titles, initial letters and to stress any important words or phrases. Experiment by cutting up your roughs to judge the different effects of colour against plain text. A pot or block of red poster paint, preferably vermilion, is adequate to start with, cerulean blue and grey also contrast effectively with black or sepia lettering.

A Saxon Song

Tools with the comely names
Mattock and scythe and spade,
Couth and bitter as flames,
Clean, and bowed in the blade,
A man and his tools
Make a man and his trade

Leisurely flocks and herds,
Cool-eyed cattle that come,
Mildly to wonted words
Swine that in orchards roam
A man and his beasts
Make a man and his home

Children sturdy and flaxen
Shouting in brotherly strife,
Like the land they are Saxon,
Sons of a man and his wife,
A man and his loves
Make a man and his life

Poem by V. Sackville West

9 Left-handed calligraphy

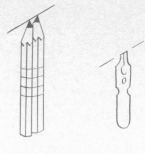

Left oblique writing implements are needed.
Double pencils should be fastened together so
that the line between the two points is at a left
oblique angle. Left oblique round hand nibs
are easily available.

The paper should be to the left of the centre-of-the-body line
and at an optional slant top right to bottom left. The writing
implement should be held in such a way that its shaft is in line with
the forearm. It should not be gripped too near the point. There
should be adequate light coming from the student's right-hand side.

The ease with which a left-hander learns lettering often
depends on the pen hold which has been developed since childhood.
Many left-handers have no trouble at all in writing a Foundational
Hand which is indistinguishable from that of a right-hander.
However, it is very difficult to teach a left-hander who cannot
change an 'over the top' pen hold when the pen can only be
pushed and not pulled downwards. Others find it difficult to get the
pen around to 30° and even more difficult to 45° in order to write
italic script (see p. 40). In this case I suggest they write their own
equivalent of a 'straight pen' or Uncial alphabet as shown on pages
34, 60 and 61. Then when they are more experienced and
consistent letterers a few 30° pencil lines can be drawn on the sheet
to help them change their pen angle.

Left-handers with any problem, whether in handwriting or
lettering, need as free-flowing a writing instrument as possible. So
any of the different makes of broad nibbed fountain or cartridge
pens may help to achieve a freer rhythm. I do not recommend these
pens for regular use, especially for large lettering, as the nibs are
too inflexible, but to help overcome a difficulty or for small
informal writing they can be very useful.

It is difficult to be specific, for the problems of left-handers are
enormously varied. Some of these ideas will help one person and
some another.

Father
Christmas

Written by a 15-year-old student at her first day-school.

Bacchanalian
Dance

Early work by a student who initially had trouble with 30° angle, but solved it, and went on successfully to Formal Italic.

ijlnmhr ace
bold toy vex

This student could produce some good letters but still finds it difficult to produce consistent lettering. She finds an italic fountain pen with left oblique nib helpful.

31

10 Other basic alphabets

The versatile calligrapher should command a variety of hands. The style, size and weight of the lettering, as well as the colour, can be chosen to fit the character of the subject matter and the mood of the scribe. This is the creative side of calligraphy, using formal writing as an art form. Experienced calligraphers will adapt these basic alphabets, mostly derived from Renaissance writing, to reflect their own individuality. Many develop an informal italic hand for general use. Others, like myself, use a quick upright compressed hand, always returning to the classic hands when formality is required.

The alphabets that follow are: Two variations on the Foundational Hand, Compressed, 'Gothic', Cursive and informal italic. Each has its own distinctive pattern and different uses.

abccdefghijklmnopqrsstuvwxyz &

A compressed alphabet written for me by M. C. Oliver when I was a student

The compressed hand is easy to learn. The small letters are just a narrow version of those of the Foundational Hand and the same capital letters are used. Capitals should not be compressed unless it is essential to fit them into a limited space.

This is a useful rather than a decorative hand. Its even pattern, helped by firm bases to the letters, makes long passages of lettering easily legible. Being narrow, it is more economical and easier to space.

Your Royal Highness

The term *italic* is used to define a sloping, or compressed letter. 'Formal italic' is a large version where, because of its size, the serifs and bases need careful attention. It is most suitable for headings or short passages of text.

32

Dirty British coaster with a salt-stained smoke-stack,

The 'Gothic' hand is slightly slanting and graceful, most suitable for poetry and decorative headings.

The pointed letters barely rest on the lines, making a spirited but not easily legible pattern. The vigorous, more angular capital letters lend themselves to flourishing, once their rather tricky slender forms have been mastered.

As lettering gets smaller and less formal, it must be simplified. Serifs are reduced to flicks, and bases of the first strokes of r, n, h and k, and the first two strokes of m, are omitted in the interest of speed and legibility. Eventually all finishing strokes disappear in fast cursive writing. Students will soon evolve personal styles of informal lettering.

with the field red and the cross & lions until 1835 was exercised by the occu-
silver: has been found, it is said, as the pants of the see. "Heraldry of the Church"

The monks and Bishop of Lindisfarne fled with the

Informal italic is useful wherever a lot of information needs to be fitted, decoratively, into a small space, as in this example where it contrasts effectively with a line of compressed writing.

and Alice met and talked and played games together, and the dream world. Outside the Parlour is the Red King asleep and dreaming about YOU !

Use cursive writing where speed and clarity are needed without formality, as in this detail from a panel for an exhibition.

The pen flows and is not always lifted between each stroke. It is easy to write but must be well controlled to produce an even, legible pattern.

Small Roman CAPITAL LETTERS DNMKB With Square Serifs

This has the same round letter form but uses square or slab serifs and is sometimes called the *Small Roman Alphabet*.

straight pen CAPITAL

serif

Written with the pen held straight instead of at a slant of 30°

UNCIAL MXT EFW

These letters are sometimes known as *Modern Half Uncials* and are based on letter forms used in manuscripts written between the 7th and 10th centuries, such as *The Book of Kells*. (See p. 60.)

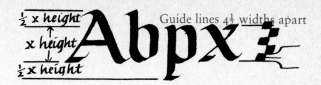

Guide lines 4½ widths apart

½ x height
x height
½ x height

Capital letters, ascenders and descenders 1½ x height

abcdefghijklmno
pqrstuvwxyz

Use Foundational Hand capital letters with compressed small letters.

iljmnrhu

Practise these letters first to get an even degree of compression.

oceagbdpq

When round letters are compressed their sides are flattened.

vwxyzsk ft

The diagonal stroke is at a steeper angle when letters are compressed.

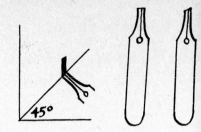

When writing all italic hands the pen is held at 45° to the guide
lines. For large formal italic use round hand nibs. For small
informal italic there are special italic nibs for right- and left-
handers. Guide lines are spaced 5 pen widths apart. Using the same
sized nib with differently spaced guide lines and a more sharply
angled nib considerably alters the weight of the letter.
Compare the different weight and shape, axis and angle of arches
and o's, and the changing angle of the diagonal strokes in:

1 Foundational
2 Compressed
3 Formal italic, and
4 Gothic hands

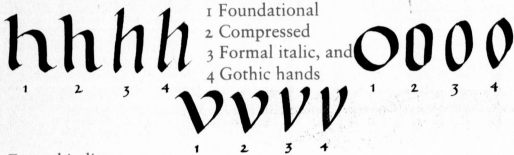

Formal italic sequences

ijl ·nmhru·

The arch branches from halfway up the stem of the letter.

oecagdbpq

vwxyzsk ft

Guide lines 5 pen widths apart

x height Abpx

Capital letters, ascenders and descenders 1½–2 'x' height

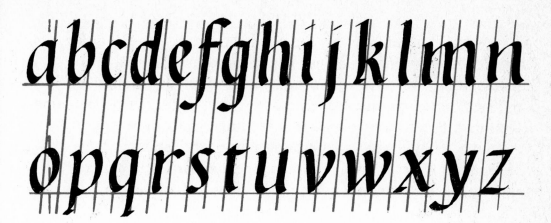

This italic alphabet is written at a 5° slant. It may be helpful for a beginner to rule a few pencil lines to keep the lettering at a constant angle – as well as checking the pen angle of 45° from time to time.

Capital letters, ascenders and descenders 1½–2 x height

abcdefghijklm

nopqrstuvwxyz

This might be more accurately described as pointed italic.

&ʒʒ ABCD

EFGHIJKL

MNOPQRS

TUVWXYZ

Translated Aucassin & Nicolete from a C13

Anonymous Provencal Ballad. R. Waley scripsit 1950

Who would list to the good lay
 Gladness of the captive grey?
Tis how two young lovers met,
 Aucassin and Nicolete,
Of the pains the Lover bore
 And the sorrows he outwore,
For the goodness and the grace,
 Of his love so fair of face

Sweet the song, the story sweet,
 There is no man hearkens it,
No man living 'neath the sun,
 So outwearied, so foredone,
Sick and woful, worn and sad,
 But is healed, but is glad
 Tis so sweet.

So say they, speak they, tell they the tale

Guide lines approximately 5 pen widths apart

Abpx

Capital letters, ascenders and descenders 1½–2 x height

The surface of the paper makes so much difference to the weight of very small lettering that it is usually better to gauge the letter-height by eye.

abcdefghijklmnopqrstuvwxyz

Simplest form

A B C D E F G H I J K L M N O
P Q R S T U V W X Y Z &

Alternatives 1. *behold* 2. *behold*

The first variation is a flick serif

Another variation is a forward stroke added to the top of each ascender except the letter 'd' which slopes backwards

minimum Exercises to develop a rhythm when writing informal hands *ijlnmrhu*
mvmwmxmymzmsmfmt
momcmemamgmbmdmpmo

40

Capital letters, ascenders and descenders 1½–2 x height

abcdefghijklmnopqrstuvwxyz

ABCDEFGHIJKLMNOP
QRSTUVWXYZ &

Cursive writing is plain but free. It
is joined-up and faster to write.

The faster these hands are written, the more
the writers individuality will show.
The borderline between informal lettering
and handwriting is difficult to define

41

When evolving a personal italic hand it is more rewarding, whenever possible, to go back to the original manuscripts rather than to study only from derivative forms.

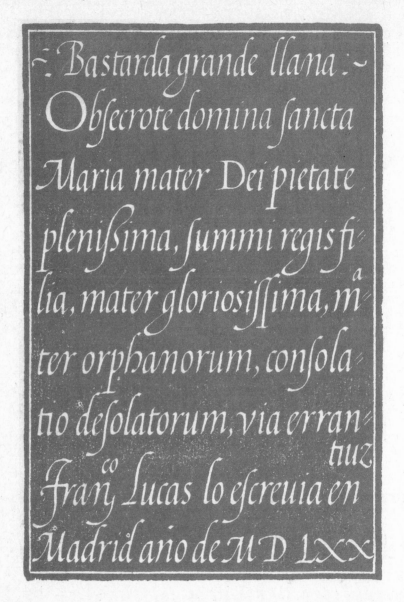

A page from *Arte de escrevir* by Francisco Lucas, a writing-book with woodcuts of scripts printed in Spain in 1577. (Victoria and Albert Museum. Crown Copyright.)

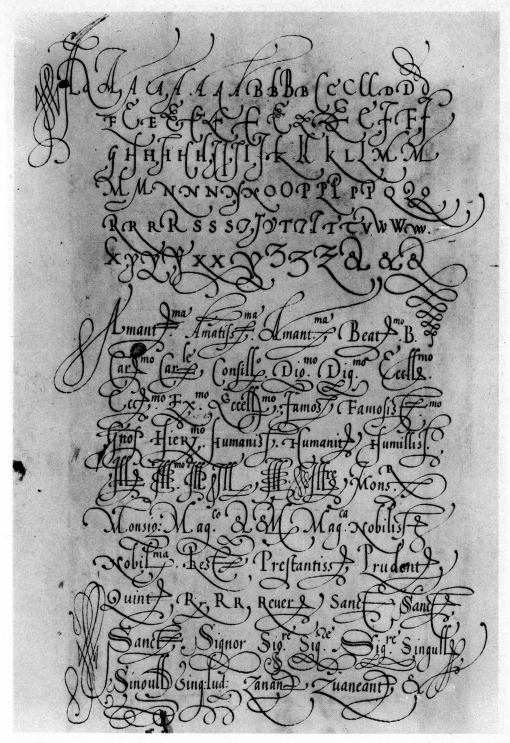

Page from a manuscript written on vellum by Francesco Moro in Italy, about 1560–70 (Victoria and Albert Museum. Crown Copyright.)

Versals *Capital letters built up with a pen*

Versals is the name given to the written capital letters of the medieval scribes, derived from the incised letters found in Roman inscriptions (see frontispiece)

Use a fairly narrow nib to outline the letters, giving the uprights a slightly waisted appearance. Use the full width of the pen for the double strokes and single cross-strokes, with the hairline used only for serifs. Flood the letters with a firm third stroke of the pen.

ABCDEFGH

Wide letters: O C D G Q M W. Medium letters: H U A N T V.

IJKLMNOP

Narrow letters: I J B E F K L P R S X Y Z.

QRSTUVW

Uncial forms XYZ

ꝺ e ꬲ ꝿ h ʀ ꭲ ꝡ

CIRCUMSCRIBING

All upright strokes must radiate from the centre of the circle

REVERSED

INFORMAL AND OPEN

Initial letters look better in a contrasting colour.

Praise
In the
Open
Also

1

Ethere
ven
the
before

2

Othat
ne
at
how

3

Versals can be set: 1 Outside the text, 2 Inside
the text, 3 Half in and half outside the text
When outside, the text letters should be centred
on a perpendicular line.

Initial letters can be given extra weight with a background of
colour or pattern, either fitting the shape of the letter or making a
rectangle around it.

45

11 Combining different hands

Having mastered a variety of hands, and bearing in mind their special uses and limitations, the calligrapher must next consider contrast of weight and colour. This can be achieved by using different sizes of the same hand, as shown below in the Golf Club notice or in any combination of capital letters, small letters and different alphabets.

Knole Park
Ladies' Golf Club
Hole In One

Name	Hole	Length	Date
Mrs H. C. Mumford	5th	123 yds	4-5-50

Any sizable block of text (as on pages 50–51) should be completed first, without interruption if possible, as even a short break can cause a noticeable change in the angle or weight of the lettering. Then rough copies of any headings, illustrations or smaller blocks of text should be cut up and laid on the finished work to judge the final weight and spacing. Not only does one's own lettering vary from day to day, but the change from a layout on practise paper to finished work on vellum or handmade paper can completely alter the weight and balance of the design.

It is an interesting exercise to letter, and then compare, the same text in different layouts, sizes, colours or combinations of hands.

46

Wrapping Material
supplied by
Waxed-Papers Ltd
Factories at Peckham S.E.15, Merton S.W.9
and Johannesburg S.A.

A notice for a trade fair written in dark red on grey

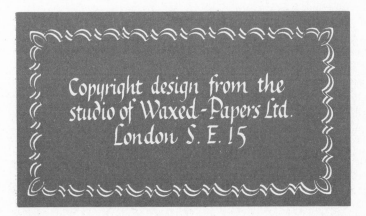

nor this alone, they give new views to life and teach us how to live
THIS BOOK BELONGS TO
Jane Scott
10 HOPE ST. LINCOLN
This books can do . They soothe the
& confirm the wise
grieved, the stubborn they chastise, fools they admonish

Copyright design from the
studio of Waxed-Papers Ltd.
London S. E. 15

A border of wording or pattern can be very effective.

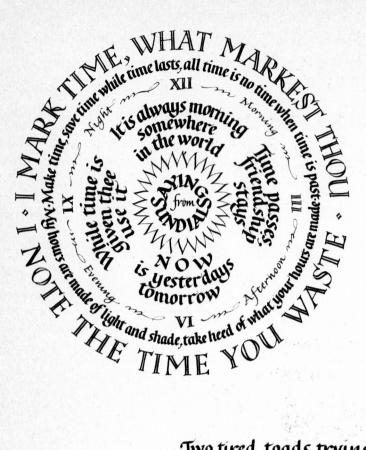

Circular or rectangular designs, with or without illustrations, are decorative and offer very good practice at a relatively early stage. Spirals can be freely written with the help of a flexible rule, or constructed geometrically. Writing can read continuously round the shape or be reversed halfway for easier legibility.

48

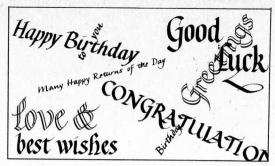

An easy and effective way of using contrasts of size, style and colour, if desired, to produce an interesting layout. This one-colour birthday design would make an unusual card or all-over repeat for packaging.

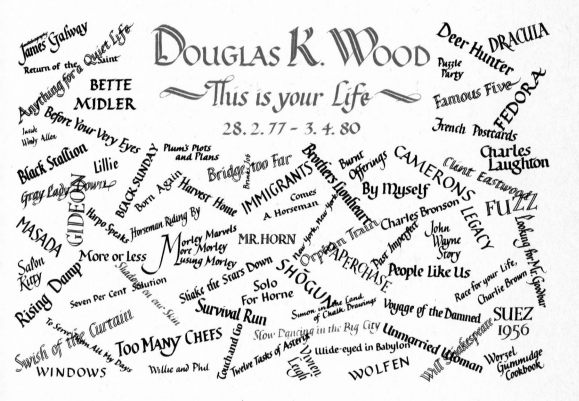

In this leaving card, designed for someone retiring from publishing, all-over lettering solved the problem of how to fit numerous titles, decoratively, into a limited space.
A 'scroll' nib used for the open lettering, double-pointed, works on the same principle as a double pencil.

THE BOROUGH OF TELSTON

At a meeting of the Council of the Borough of Telston on tenth day of June 1949, held in the Guildhall of the said borough, his Worship the Mayor presiding, it was unanimously decided that this Council do hereby confer upon

Sir John Fenter

The Freedom of the Borough of Telston The most honoured distinction which it is their privilege to bestow in recognition of the services that he has rendered to his borough and county during the twenty five years which he has held office as a councillor of the Borough of Telston. We record with gratitude his tenour of office and his unceasing efforts to further the cause of the under privileged. His constant helpfulness, thoughtfulness and understanding have endeared him to the many citizens of Telston who have benefitted from his advice & assistance, and his fellow members of the Council, who look forward to his guidance for many years to come.

Presented to Sir John Fenter with an inscribed piece of silver, by His Worship the Mayor at a ceremony in the Guildhall of Telston on the ninth day of September 1949

The versals and name are in red, small italics in grey and the coat of arms in blue, black and red.

A PRAYER FOUND IN CHESTER CATHEDRAL

Give me a good digestion, Lord,
 And also something to digest:
Give me a healthy body, Lord,
 And sense to keep it at its best.
Give me a healthy mind, good Lord,
 To keep the good and pure in sight:
Which seeing sin is not appalled
 But finds a way to set it right.

Give me a mind that is not bored,
 That does not whimper, whine or sigh:
Don't let me worry overmuch
 About the fussy thing called "I."
Give me a sense of humour, Lord:
 Give me the grace to see a joke:
To get some happiness from life
 And pass it on to other folk.

The cathedral church of Christ & the Virgin Mary stand within the city walls on an ancient site. In 1005 Hugh Lupus, earl of Chester, richly endowed the foundation as a Benedictine monastery. Chester was erected into a bishopric by Henry VIII in 1541, the church of the dissolved abbey of St Werburgh becoming the cathedral.

51

12 Flourishes

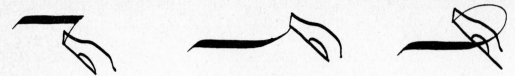

Use only the inner edge of the nib when finishing a stroke, either flicking downwards or freely drawing up and over.

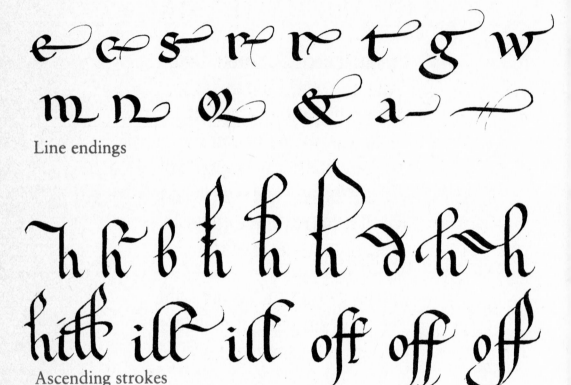

Line endings

Ascending strokes

Descending strokes

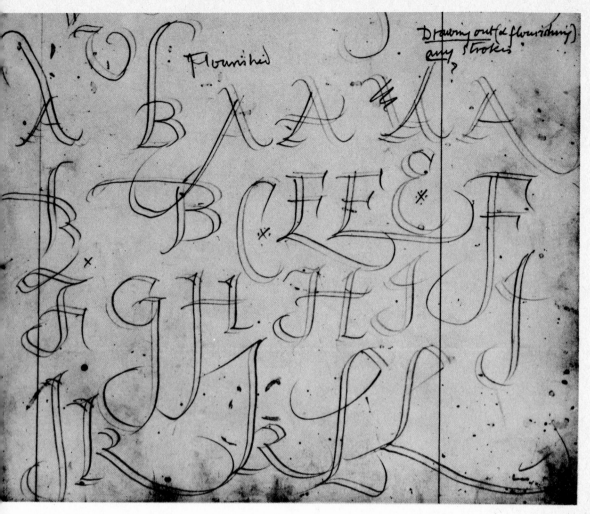

Flourished double-pencil capital letters by Edward Johnston.
Reproduced by kind permission of Dorothy Mahoney.

Use flourishes sparingly
for greatest impact.
Flourished headings or
monograms need careful
designing, making sure
that when extending any
stroke of a letter, it is
enhancing the letter
form, not distorting it.

53

Flourishes: words and patterns

To add height and weight to headings

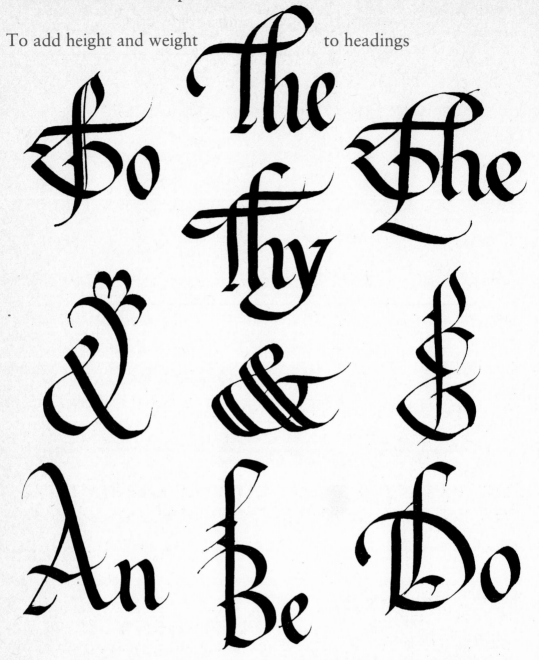

Pen-written pattern adds colour and weight to the bottom of a layout. This example was used on a civic scroll for Sevenoaks.

Repeating patterns based on flourished letters, such as this letter F, are good practise and make decorative endpapers or bookcovers.

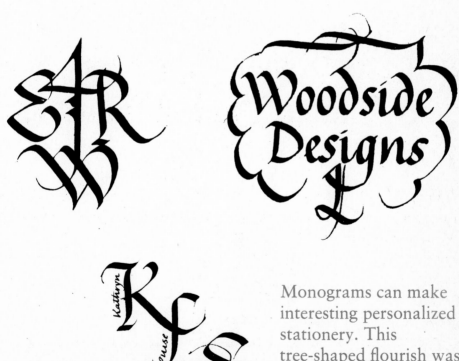

Monograms can make interesting personalized stationery. This tree-shaped flourish was designed as a letter-heading for an interior decorator.

55

One of the key lines of this poem is:
'*A Lillee of a Day is fairer farre in May.*'
The heading was in cerulean blue with
the text in sepia. This was lettered
as a memorial for a friend's child.

The
Burne
by Ben Jonson

To
Her Most Gracious Majesty
Queen Elizabeth the Second
and
His Royal Highness
Prince Philip Duke of Edinburgh

Heading for a loyal Address in the Silver Jubilee Year
Ornamentation is not always needed; plain, dignified lettering is
suitable even for the most ceremonial occasions. At other times one
can be more imaginative:
this heading for a
presentation poem
was written
in green.

The
Green-sailed Vessel

To make Incke

Le Conseil Municipal d'Edenbridge

envoie ses meilleures salutations à ses amis de

Mont Saint Aignan

These three headings were all written in red for use with predominantly black text.

The Charter

13 Materials for more advanced work

Better equipment and materials are needed to achieve a really high standard of calligraphy. A hinged board on an adjustable base, or an architect's table, to ensure steady support at any angle is essential.

For presentation lettering the quality of the actual paper is obviously important. A parchment coloured paper may prove more sympathetic than dead white (and may be less apt to discolour with age) and a deckle edge can often lend distinction to the finished work. A handmade paper is best, but this is increasingly difficult to find, and expensive too. Surfaces vary from smooth 'Hotpress' to more textured 'Not' papers, the weight of the paper again affecting its writing properties. Some may prove especially good for fine writing, others for larger work. It is often a matter of personal preference whether to use a smooth paper or one with more 'tooth' or resistance to the pen.

Experiment also with good machine- and mould-made papers. Smooth, laid or textured papers all prove their worth for different purposes. I have used at least six different types of paper while preparing the lettering for this book.

Chinese or Indian stick ink, freshly rubbed down for use in a slanting palette, makes a free-flowing black. When not too dense, it tends to dry darker at the base of each stroke, giving an interesting balance to a line of lettering.

Artist-quality watercolour, in a tube or pan, is probably the best for fine work. A tube is more convenient to use, but the pigment dries more slowly than that from a pan. Scarlet vermilion, cerulean blue mixed with a little ultramarine, and viridian green are the nearest modern equivalents to the heraldic colours *gules*, *azure* and *vert*.

The traditional natural materials, vellum and quills, produce incomparable results in skilled hands. However, vellum is difficult and expensive to obtain, and needs special care in preparation, stretching or framing. Quills require careful selection, drying and cutting, and constant trimming during use. They are counter-productive if not correctly used.

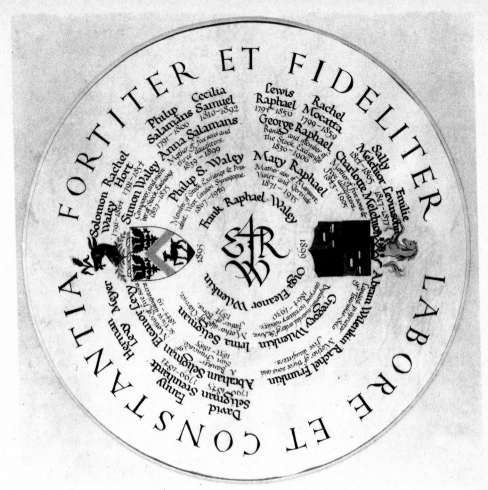

Family tree written in red, black and gold on vellum.

Gilding – the laying of size and gold leaf which is then
burnished – is best carried out on vellum, and again is a
complicated procedure. There are several commercial preparations
that can be applied with a brush onto paper; these can be quite
effective if used sparingly.

Heraldry is a fascinating and complex study. Coats of arms
and heraldic creatures or devices may be used wherever appropriate
as ornament to calligraphic texts but great care must be taken to be
accurate both in the drawing and colouring.

It is not possible to cover these advanced techniques in a
relatively short book. For further information students should refer
to *Writing and Illuminating and Lettering* by Edward Johnston
(Pitman Publishing Ltd).

14 Studying and using historical hands

When approaching a new alphabet or passage from a manuscript that you wish to study or copy, divide the letters into sequences of those comprising the same strokes. This way you will quickly learn their special characteristics and become consistent in copying or adapting them to your own needs. The letter sequences may vary from one alphabet to another, and there are usually several letters that bear no stroke resemblance to the others.

An alphabet should, where possible, be chosen to suit the language of the text. Classic Roman letters may look inappropriate for a Celtic name, and a German text seems to look better in traditional Black letter, which suggests that there is probably a visual association of language to letter in most people's minds and that some languages look better when written in the hands evolved for them.

Since writing is as much a legacy of the past as architecture or painting, I find that using the styles and tools of a different age gives me an insight into the period.

Uncials

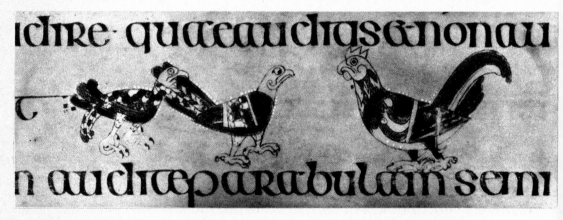

An example of Irish Half Uncial from *The Book of Kells*.
Trinity College, Dublin.

Double pencil uncial capital letters by Edward Johnston.
Reproduced by kind permission of Dorothy Mahoney.

ABCDEFGHIJKLMNOPq
RSTUVWXYZ abcdefghijk
lmnopqrstuvwxyz

Modern half-uncial alphabet written out for a student by Edward
Johnston, *c.* 1930
These letters are written with a straight pen.

IFOR EVANS

From a retirement scroll written by the author.

iljrnmhuyvw

ceoabpqgd

tfɽskʒ

A simplified Gothic or black letter alphabet
The letters are constructed almost entirely of straight lines.
Spacing is important to produce the characteristic even texture of
Gothic script.
The space between letters should be equivalent to the space
enclosed by each letter.

Aabcdefghijklmnopqzrſsſstuvwxyz.xc.
ABCDEFGHIKLMNOP
QRSTUWXYZZIC

This alphabet appears in *The Universal Penman*, engraved by
George Bickham in 1743.

A a b c d e f g

honnenr et

feruice a dieu

a b c d e f g h i

Assez demande

qui bien sert

An elegant Black letter (*Lettre de forme*) and the so-called *Lettre Bastarde*, both from *Champ Fleury* by Geofroy Tory.

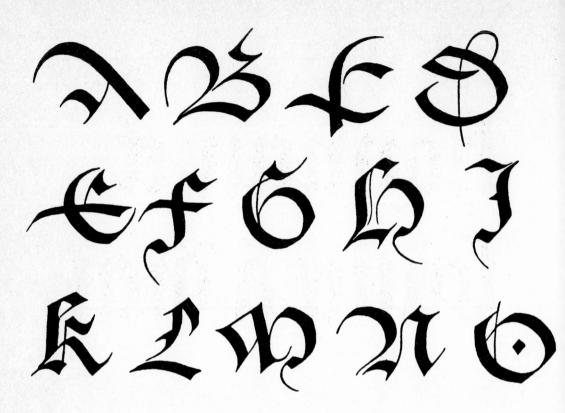

Capital letters by Geofroy Tory. From *Champ Fleury*, 1529.
Not all of these forceful capital letters are immediately legible
today; but those used for these honey-jar labels needed no
attention, although I simplified the small letters considerably.

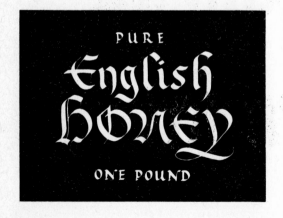

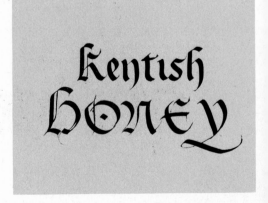

so proŋe aŋd ready to labour as hit hath beŋ, aŋd that age crepeth oŋ ɱe dayly aŋd febleth all the bodye.

Lettering played an important part when I worked with a team of designers on a travelling exhibition of the history of writing and printing. It not only added to the general atmosphere, but by writing the notices and quotations in a simplified, enlarged hand incorporating some of the unfamiliar letterforms of the 15th century, we sought to help the public decipher the original manuscripts on show, many concerned with William Caxton. On tour, simple hand-lettering enabled last-minute alterations to be practical and financially possible.

Postcard for sale at printing exhibition. The larger lettering was written with double fibre-tipped pens and painted in.

for they Wende that they Wolde haue amended her tatches / & hyr Wicked the Wes / But of suche condicions they Were / that for fayre speche & Warnynge, they bydden al the Wers) and for setynges

Early Caxton typeface which resembled his own handwriting

65

It takes endless practice to develop a good copybook
or copperplate hand. The technique is different from that of
present-day handwriting or lettering with a broad-nibbed
pen. Differing pressure on the fine flexible nib makes the
thick and thin strokes. In the extremely controlled letters the
downstroke is heavy and the upstroke thin, the arches and often
unfamiliar ligatures are rounded and very finely written.
In decoration the weights of the strokes are changed at will.
 The Victorian copybook method of repetition of a short
saying is the best way of developing a regular hand.

Health is valuable

Health is valuable

Gaming is a wicked cust.

Gaming is a wicked cust

Excerpts from two pages of a copybook written by Joseph Wilkes
in 1840 when aged 14 years (Reproduced by kind permission of his
great-granddaughter, Anne Isobel Jackson). Copperplate writing
evolved as people tried to copy with their pens the controlled but
flowing strokes of the copper engraver's burin.

66

Aim at improvement in every line.

Business makes a Man respected.

Commendation animates the mind.

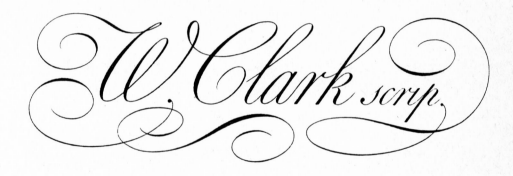

The difference between these two illustrations is that John Wilkes's work is photographed from his original copybook writing with its extremely fine, sometimes broken hairlines, not easy to reproduce but nonetheless much closer to the effect that students will be able to reproduce by their own efforts.

The William Clark example was reproduced by being engraved by George Bickham and it appeared in 1743 in his book *The Universal Penman* (a facsimile of which has been printed by Dover Publications). Engraving produces a more continuous and even fine line than is possible with a pen.

Studying and using historical hands: Copperplate or 'Roundhand'

This enlarged alphabet is useful because it shows the construction of the letters.

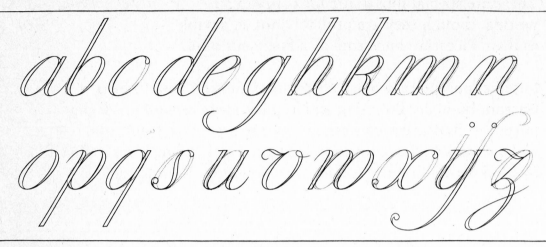

From a Copy Book Written for the Use of the Young Gentlemen at the Academy in Greenwich. By Thomas Weston, 1726.

How to construct a flourish
By Edward Cocker from *Magnum in Parvo or, the Pen's Perfection*, 1672 (both Victoria and Albert Museum. Crown Copyright)

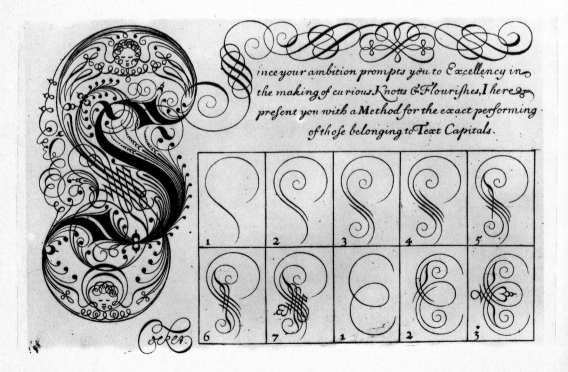

There are special nibs made for copperplate writing, though they are probably not as flexible as their Victorian ancestors or a finely cut quill.

I used copperplate extensively in an exhibition about Lewis Carroll, both small writing and a quick large version for display purposes. Recently I was asked to write a passage from John Clare's work for an educational book. The heading is reproduced by kind permission of Hodder and Stoughton Educational.

Larger lettering, where the letters are outlined with a thin drawing nib and filled in by brush, is usually referred to as script lettering, and is extremely useful to a designer. An excellent reference book is *Tommy Thompson's Script Lettering for Artists* (Dover Publications).

This nameplate was designed for the makers of fine keyboard instruments

half an inch

equals $4\frac{1}{2}$ times size o, the largest round hand nib. If you want to produce larger lettering using the same letterforms, correctly proportioned, other implements must be explored.

Various large nibs which are meant for poster work, are available. However, broad metal nibs tend to be rigid, and it is difficult to produce really good lettering with them. They are best used only when simple non-serif letters are required.

Thin balsa wood cuts easily to make a large flexible writing tool. This letter was written with a pen made from the side of a match-box. It was cut across the grain with a sharp pair of scissors and wedged into a soft stick for a handle then dipped in ink.

These rectangular-leaded pencils are very useful for quick notices, and can produce excellent results when skillfully used. They need careful and frequent sharpening of all five planes of the lead. Finished work must be sprayed with fixative.

They can be cut down in size
and look very effective when used on textured coloured paper

A wedge shaped fibre tipped pen is. also useful.

Pens can be strapped together and used like double pencils
Measure $4\frac{1}{2}$ times the distance between points for correct letter size

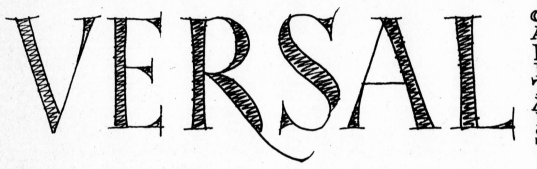

Can be written fairly freely and large with felt or fibre-tipped pens.
They can be filled in or left

Double letters

Double letters can be constructed to enlarge the scale still further, using two strokes for thick lines and one for thin.

reduced

double

Can be even larger still

73

Brush Letters

develop quite naturally from pen lettering

Letterforms
of the
foundational
hand

can be produced just as easily with a brush

a Character Script

can be evolved to suit any subject or mood.

Use a good quality medium-sized brush.

Vary *in size* and shape

or Thick thin

To suit subject and layout

round and Square

Letters are formed by varying the pressure and amount of ink on the brush.

Speed and Freedom are the advantages of brush scripts

Baby

Fat

dry

An Announcement

MADE IN ENGLAND

closed

Free

open

Flowers

Congratulations

Sale
Sale
Sale
Sale
Sale
Sale
Today

Greetings

Advertising

Wrap fresh food in foil

Birkett's
Milk Loaf

17 Preparing work for reproduction

Preparing lettering specifically for reproduction poses certain problems for the calligrapher. These can usually be overcome, provided that one has enough information before starting work. For instance, it is important to know whether the lettering will be reproduced in the same size or in a reduced version. Reduction can help to eliminate roughness or unevenness, but it can also show up faults in spacing, and it is often difficult to judge the effect in advance. Viewing the work through a reducing glass helps one to spot such faults before the work is submitted. Remember that when pen lettering is reduced, the thin strokes made by the edge of the nib, which remain the same however thick the width of the pen, will become very thin indeed and may disappear altogether if the reduction is too great. I usually like to work about one-half up for reproduction but nearly all the pages which were specially prepared for this book were written to the same size.

The nuances of texture which add interest and beauty to an original piece of calligraphy are invariably lost in reproduction, so there is no point in using expensive paper or vellum. The best results are achieved by working on a smooth white paper (not card or drawing board, as this is not resilient enough) and by using a uniformly black ink. I use a liquid bottled watercolour which flows easily but is very dense. Unfortunately this cannot easily be touched up since it is non-waterproof, so if corrections are anticipated it is best in this one instance to use waterproof ink.

In cases where the lettering is to appear white on a black ground, which can be very effective for certain types of work, it is much easier to work in black on white paper rather than attempting to use white paint. The result can then be photographically reversed. When working in this way, it is important that the hair lines do not become too thin and risk closing up.

When more than one colour is to be used, it may be more economical for your client if you do this on a transparent overlay (using a special transparent film or thick tracing paper) or by a keyed drawing, making the separation yourself rather than leaving it to the printer. If in doubt, always seek advice.

Chatham Vellum represents the result of a five year research programme. It is made entirely from raw flax - the fibre from which linen is woven and which was the very foundation of European paper-making for centuries. We have combined this with an advanced sizing system which results in an acid-free paper with first class writing properties.

Four deckle edges and the delightful flax-en tone which is entirely natural - no colours are added - combine to give a character suitable for the finest work.

Full details are given overleaf

The inside is blank for you to test

Chatham Vellum

Hand-made Calligraphy Paper from Barcham Green

A brochure for a paper manufacturer. The original was lettered one half up.

The examples on the following pages show some of the many practical uses for calligraphy.

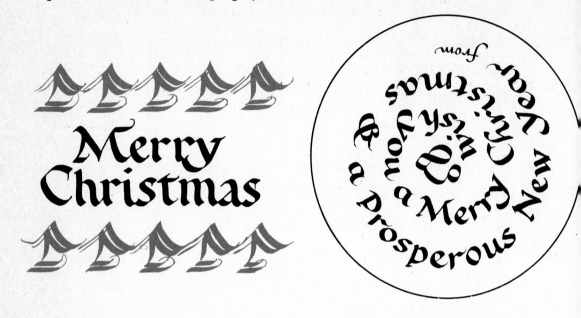

Cards for all occasions

These simple designs can be lettered in one or two colours, or more carefully prepared as finished drawings for reproduction.

Some first-year students' cards

A Precious Oyntment for all Manner of Aches

Take a pound waight of Sage, as much
Rew, half a pound of Wormewood
and as much Crops of Bayes, &
beat them very small in a Morter
Take two pound and a halfe of
Sheepes Tallow & temper it with
the hearbes that be beaten, put in
a pan & set them on the hot embers
Put thereto a Pottle of Oyle of
Olife and let it stand upon the
Embers two houres and a halfe
at the least, then strain it
through a course cloath and
put it in an earthen pot & so
occupie it This would be made
in May or June.

From
The Widdowes Treasure 1595

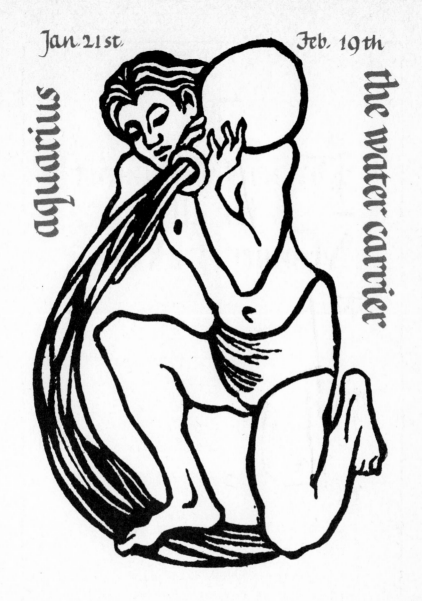

Jan. 21st Feb. 19th

aquarius the water carrier

Zodiac birthday card. Lino-cut by Pat Savage, printed in black with cerulean blue lettering.

Left. Quick sketch for a 'Get well soon' card.
In this case it is the content, not the design, that provides the interest.

Film titles
These were lettered in white
on a dark blue ground and
touched up with a brush.
Reproduced by permission of
Matthew Nathan.

A Film of
Italian
Mediæval
Pageantry

TUSCAN
TAPESTRY

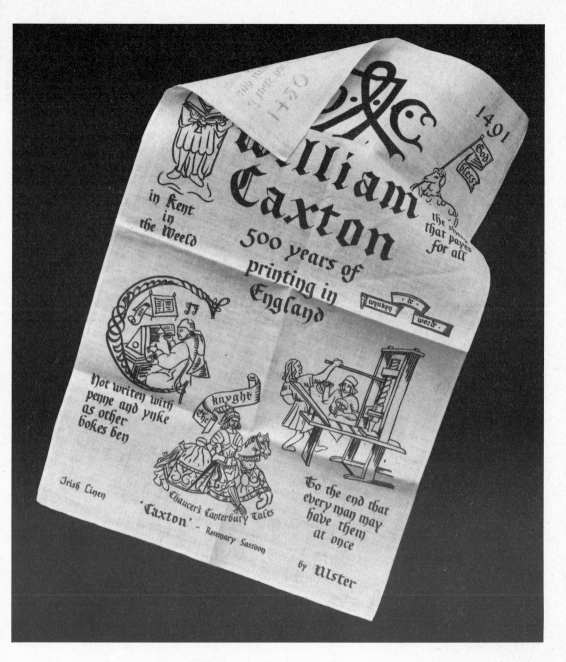

Tea towel printed in black on linen by the Ulster Weaving Company Ltd. This was designed for the Caxton exhibition (see p. 65).

(see p. 65).

Lettering can be used effectively in textile design, smoother material obviously being more suitable for smaller lettering.

Peacock

Research in the British Library provided eight different 16th- and 17th-century recipes from early cookery books for use on large table-mats and their accompanying coasters. Printed in sepia on parchment coloured paper.

From a 17th. English Recipe

how to BAKE A HARE

Bake a Hare, being parboyled & break his bones that they start not up and break your Pye, lard with bacon & season, your Coffin being ready in the proportions of a hare, so put it in with herbs close your Pye, indore & bake it.

Thyme

Thymus Durius

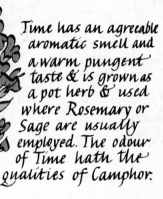

There be two sorts of Garden Time among the old writers, the latter Herbarists have found more. Thymus Durius, or Common Garden Time is so well known that it needeth no description.

Time has an agreeable aromatic smell and a warm pungent taste & is grown as a pot herb & used where Rosemary or Sage are usually employed. The odour of Time hath the qualities of Camphor.

Time boiled in water and honie, and drunken is good against the cough & shortness of breath

From a set of eight different 'herbal lore' designs printed in colour. All these were made into mats by Lady Clare Ltd, Lutterworth, Rugby.

Camomile

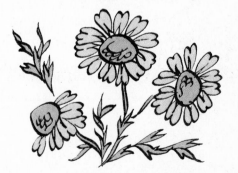

Anthemis Nobilis

Anthemis Nobilis

Anthemis Nobilis

Camomile

Calendar

The finished drawings for the illustrations were worked in white on a black ground and the strokes were then thickened where necessary to allow for the slight narrowing that would occur during letterpress printing. Each page was printed in an appropriate colour and black.

88

Cover printed in red, black and gold.
Reproduced by kind permission of J. Salmon Ltd.

Calligraphic patterns

Mat designs. Reproduced by kind permission of John Lewis
Partnership.

There were three large and three small designs. The small ones used
simplified versions of the same shapes rather than reductions.
Finished drawings were worked $1\frac{1}{2}$ times size. Geometrically
measured and marked out and the pattern traced down, the
drawing was rotated as each segment was completed.

Calligraphy at work (continued)

Repeating patterns
A single motif, either of pattern or words, can be repeated to form an effective all-over design for use on textiles or paper products.

TO ROAST A PIGGE

From an Elizabethan recipe

Take your Pigge and draw it, wash it cleane and take out the liver. Perboile it and straine it with a little creame and yolkes of egges, put these to grated bread, marrow and small raisons, nutmegs in powder, mace, ginger & salt, stirre all these together, put into the Pigges bellye, sowe it then spit it with the haire on. When it is halfe enough pull off the skinne, baste it, and when it is enough crumb it with white bread, sugar, sinamon and ginger, let it be somewhat browne and so serve it.

Your Crabs being boyled, take the meat out of the bodies and barrels and save the great claws and small legs whole to garnish your dish. Strain the meat with some Claret wine, grated Bread, Mace, Nutmeg Salt and Butter, stew them together for one quarter of an hour on a soft fire in a Pipkin, and being stewed almost dry, put in an egg yolk with the juice of several Oranges, beat up thick, and put the meat in shells. Dish the legs round about & serve.

To make A PARTRIDGE TART

From a 17th Century recipe

Take the flesh of four or five Partridges and mince them very fine with the same weight of Beef marrow as you have of Partridge flesh, two ounces of Orangeadoes & green Citron minced together as small as your meat, and season with Cloves, Mace, Nutmeg, a little Salt and Sugar. Mix them all together and bake in a Puffe Paste When it is baked, put in half a graine of Muske or Amber brayed in a Morter or Dishe and a spoonful of Rosewater & Orange juice and so serve it up

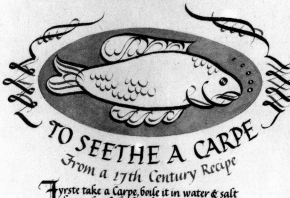

TO SEETHE A CARPE

From a 17th Century Recipe

Fyrste take a Carpe, boile it in water & salt then take of the broth, put in a pot and put thereto as much wine as there is broth, with Rosemary, Parslie, Time Marjoram, bounde together, put thereto as much of sliced onyons, small raisons, whole Maces, a dishe of butter and a little sugar so that it be not too sharpe or too sweete, and let all these seethe together If the wine be not sharpe enough then put thereto a little vinegar. And so serve it upon soppes with the brothe.

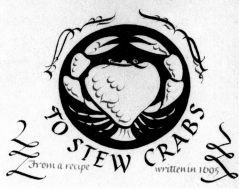

TO STEW CRABS

From a recipe written in 1605

Repeating design for a wrapping paper. By permission of Brown, Knight and Truscott Ltd.

The aim of this book has been to give the beginner who is prepared to persevere a grounding in the basic skills of pen and brush lettering and to suggest ways in which these can be developed and used.

I hope it may also have suggested how the study of calligraphy can increase one's awareness of the relationship between the words, whether prose or poetry, and the manner in which they are written. This is something which is difficult to explain or teach. One can only say that the ability of the trained hand to put on paper the image in the mind's eye – sometimes with results which may surprise the creator – and the insight this can give one into the meaning of the text are among the rewards which can come as a result of practice and self criticism, both of which are essential for the committed calligrapher.

I should like to think that the historical examples I have included will encourage some people to look more deeply into the fascinating history of writing. Manuscripts are all around us; in museums, libraries, local archives and churches, perhaps even in our own attics. The letter forms which surround us on all sides, whether written, carved or printed, influence our lives at every level; the road signs which direct us, the typeface of the books or newspapers we read every day, the graphics on the television screen and the lettering on packaging or advertising which helps to sway our choice.

There need be no artificial divisions among these varied forms of lettering. Each has its own function and usefulness. The study and enjoyment of them can teach us a great deal and help us to widen our horizons.

Additional reading

EDWARD JOHNSTON. *Writing and Illuminating and Lettering.*
 Pitman. Reprinted in paperback 1977
A Book of Sample Scripts. HMSO. 1966
ALFRED FAIRBANK. *A Book of Scripts.* Faber and Faber. 1977
 A Handwriting Manual. Faber and Faber. 1975
JOYCE IRENE WHALLEY. English Handwriting, 1540–1853.
 HMSO. 1969
JOYCE IRENE WHALLEY and V. C. KADEN.
 *The Universal Penman. A survey of western calligraphy from
 the Roman period to* **1980.** HMSO. 1980
DAVID KINDERSLEY and LINDA LOPES CARDOZO. *Letters Slate Cut.*
 Lund Humphries. 1981
TOM GOURDIE. *Calligraphic Styles.* Studio Vista. 1979
The Puffin Book of Lettering. 1961
DOROTHY MAHONEY. *The Craft of Calligraphy.*
 Pelham Press. 1981
DONALD JACKSON. *The Story of Writing.* Studio Vista. 1981
EDWARD M. CATICH. *Reed, Pen and Brush Alphabets.*
 David and Charles. 1980
ALBRECHT DURER. *Of the Just Shaping of Letters.*
 Dover Publications. 1966
GEOFROY TORY. *Champ Fleury.* Dover Publications. 1967
GEORGE BICKHAM. *The Universal Penman.* Dover Publications. 1964
TOMMY THOMPSON. *Script Lettering for Artists.*
 Dover Publications. 1965
S. H. STEINBERG. *Five Hundred Years of Printing.*
 Penguin Books. 1974
JASPERT, BERRY AND JOHNSON (eds.). *Encyclopaedia of Typefaces.*
 Blandford Press. 1970
A. C. FOX-DAVIES. *Complete Guide to Heraldry.* Thomas Nelson.

Useful addresses

Society of Scribes and Illuminators
c/o British Crafts Centre
43 Earlham Street
London
WC2H 9LD

Society of Scribes
Box 933
New York
N.Y. 10022
USA

Falkiner Fine Papers Ltd
4 Mart St
London
WC2E 8DE
*Worldwide suppliers of paper and
all calligraphic materials*

Philip Poole
182 Drury Lane
London
WC2B 5QL
*Specialist supplier of pen holder.
and steel nibs*

All pens and nibs illustrated in this
book are Mitchell Pens
distributed by
Rexel Ltd
Gatehouse Rd
Aylesbury
Bucks HP19 3DT
Formerly Cumberland Graphics Ltd.

Pentalic Corporation
132 West 22nd St
New York
N.Y. 10011
USA
*For pens, inks and
calligraphic books*

Acknowledgments

My acknowledgments must start with Geoffrey Holden and the late
M. C. Oliver, who trained me as a scribe. Then I would like to
thank Esther Aresty, who first suggested that I should write this
book, and Jean Ellsmoor, who saw to it that I did; Joyce Whalley
and Dorothy Mahoney, for their help and encouragement; the
manufacturers and others who have allowed me to reproduce work
which I have done for them; the many students who tested my
teaching method; and finally my husband, John, who has long
suffered from a paper-strewn home and who has spent a lot of time
correcting my grammar.